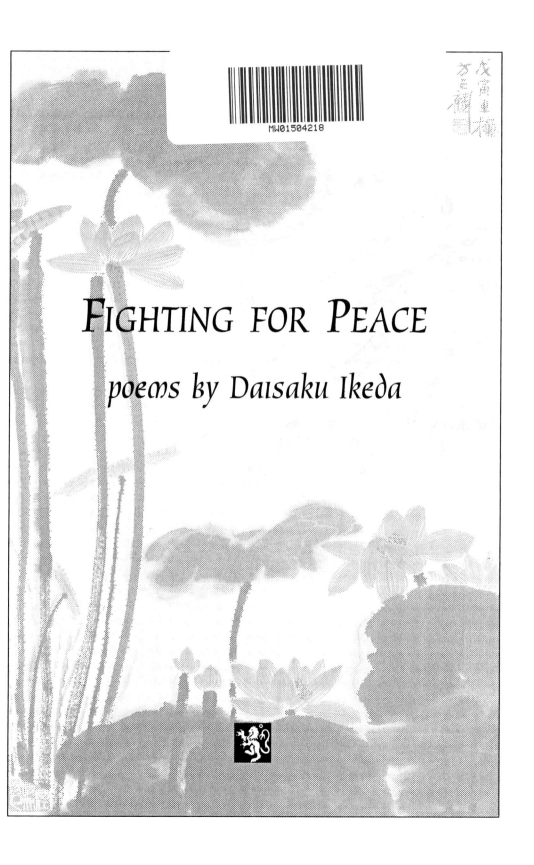

FIGHTING FOR PEACE

poems by Daisaku Ikeda

Ikeda, Daisaku.
 Fighting for peace / poems by Daisaku Ikeda;
translated by Andrew Gebert.
 p. cm.
 LCCN 2003114639
 ISBN 1-931501-00-9

 1. Peace--Poetry. 2. Buddhism--Poetry. 3. V-J Day,
1945--Poetry. 4. Humanism--Poetry. I. Gebert, Andrew
II. Title.

PL853.K33F54 2004 895.6'1'5
 QBI04-200048

Dunhill Publishing
18340 Sonoma Hwy
Sonoma, CA 95476
Tel (707) 939-9212
Fax (707) 938-3515
Email dunhill@vom.com
Order line 1-888-746-6697

Cover Illustration: *Lotus Flowers* by Fang Zhaoling

Library of Congress Control Number 2003114639

Printed in the United States of America

FIGHTING FOR PEACE

poems by Daisaku Ikeda

Translated by Andrew Gebert

Contents

Foreword

One doesn't have to be a follower of the Buddhist religion to appreciate the universal appeal of *Fighting for Peace* by Daisaku Ikeda. He speaks for the millions of people who have become frustrated with the lethal shenanigans of the world's politicians, who continue to threaten the people of the Earth and the very planet itself with destruction. Global warming and other problems of immense magnitude don't merit their attention and though some of them view themselves as leaders of democracies, their allegiance is to their corporate bosses and not the electorate.

They are concerned about the weapons of mass destruction located in every country but theirs; indeed a good part of their budgets go to the defense contractors who hold them by a leash, while thousands of their citizens live homeless in tent parks and rummage through trash cans for food.

Daisaku Ikeda's denunciation of these "imbeciles" is merciless. For him, they are "poison-scented hearts," who "reside in demonic gloom/ hissing venomous sighs." They distract the masses of people from their heinous deeds with "rude amusements." He writes of "Leaders of nations/ who cast peace-loving people/ into war's conflagration/—inflicting on them/ that horrific suffering—/ epitomize evil./ Their crimes can never/ be forgotten or forgiven."

One can understand the urgency of Mr. Ikeda's pleas for peace. He is not a wealthy Californian who uses Buddhism as a hobby. His family suffered as a result of his country's leaders' folly. Men who "maneuvered and brainwashed to extol the glories of war." The lessons of World War II have not been absorbed by today's leaders. That "the cause of war is ignorance" is as true today as it was in the 1940s.

While serving as a solider in the Japanese Imperial Army, his eldest brother was killed in Burma. His family was "forced to evacuate our home/ to stay with relatives/ in Nishi Magome./ However, this refuge,/ this house set amid peaceful fields,/ took a direct hit/ from an incendiary bomb." His family lost all of their possessions.

His predecessors, Tsunesaburo Makiguchi and Josei Toda, were imprisoned in Tokyo during World War II for their criticism of the militarist government. Makiguchi died in prison.

Though troubling, these poems are ultimately hopeful. He believes that a peaceful army whose weapons are, quoting Einstein, "weapons of the spirit," can mount opposition to "reckless arrogance/ of the powerful few."

He pictures a future world where "Everyone has the right/ to savor the highest joys./ Everyone has beautiful hopes/ that must not be violated."

What John F. Kennedy said about victory and defeat can be said about war and peace.

War has a hundred fathers while peace is an orphan.

Daisaku Ikeda is a leader of the increasing numbers of people of the world who desire to adopt the orphan.

—Ishmael Reed
Writer and Poet

Introduction

At any given moment in history, precious few voices are heard crying out for justice. But, now more than ever, those voices must rise above the din of violence and hatred. Paradoxically, science and technology that have contributed so much to improve the lot of people and raised so high the standards of living, have also created the means of utter destruction. We have reached the stage when the world and its people can no longer afford to settle disputes through violence and through warfare. The future of humankind teeters on the whims of the few nuclear states that possess the capability to destroy our planet. If the new century is to be one of peace, if we are to leave behind the fear and tragedy that has so scarred the world's landscape, then we must focus once more on the preciousness of human beings and of all life. We all want to see a world in which relations among people and nations are based on compassion, not greed; on generosity, not jealousy; on persuasion, not force; on equity, not oppression.

For over forty years, Daisaku Ikeda has traversed the globe, engaging in dialogue with many of the world's leading thinkers, and carrying the message of hope and goodwill. He wishes to embrace all people and is determined to forge heart to heart bonds of mutual acceptance and respect which will ensure a lasting peace.

Many may decry as idealistic his firm belief in the potential of each individual, but Daisaku Ikeda is unwavering in his confidence in the human spirit. Through his poetry resonates this passionate spirit, a cry to all who suffer indignity or oppression at the hands of others. His words give hope to the hopeless, strength to the weak and courage to those that have tasted defeat.

In this book of poems, Ikeda urges us to stand on the side of good for the sake of all people. But despite the tragic circumstances that fuel his call, Ikeda is not bitter or despondent. While he recognizes the arrogance and hatred that reside in human souls, he believes that there is even greater goodness, justice and morality in those very same souls. He believes without question that good will win over evil and he is willing to stand at the vanguard and open a path toward peace.

As one reads the poetry of Daisaku Ikeda, one thing becomes increasingly clear: this is a voice that speaks to all of us. This is a voice that comes from someone who has experienced life from many perspectives. And this is a voice we all need to hear.

—Joseph Rotblat
Nobel Peace Laureate, 1995
Emeritus President,
Pugwash Conferences on
Science and World Affairs

❧ FIGHTING FOR PEACE

FIGHTING FOR PEACE

The bright light of peace!
All the world
advancing in joyful harmony,
a world lit
by the bright cheer of peace!

In such a world,
our spirits grow and expand
with each passing day,
there is no lonely isolation.
For you and for me,
so powerless and alienated
on our own,
the dazzling allure
of a life fully free from
frustration and defeat.

But in a world filled with lies
genuine peace cannot be found.
True happiness or peace
can never exist where
hearts merge
in dark fusion.

The creeping approach
of devious authority,
its bombast and strife,
can never give rise
to a sure and certain peace.

In order to live
true to your sincere convictions
create a world
where many share
your earnest view of life.
Here you will find
a world of peace.

Only by confronting,
exposing, breaking open
the pompous, poison-scented hearts
of those who wield power—
only in this way
will genuine peace
be given the chance
to live and breathe,
in seen and unseen ways.

When people are ignorant
of their purpose in life,
the deadly disruptions of war
continue without cease.

Peace pledged
in sad, grim treaties
is empty and meaningless.
There must be mutual
understanding of the soul
and bonds that link the heart.

In the words of
one statesman:
> Peace is not found
> in the interval
> between one war
> and the next.

Where there is no peace,
happiness is unthinkable.
Thus Buddhism teaches the ideal that
"This, my land, is safe and tranquil."

* * *

We will struggle relentlessly
against those who would destroy peace.
We will struggle relentlessly
against those who force
their evil on others.
We will struggle relentlessly
against those who author
secret wrongs,
inflicting these
with callous abandon.

For such people are cowards.
They reside in demonic gloom
hissing venomous sighs
as they undermine
humanity and justice,
turning all
to nightmare and misery.

Whatever lies and slander
they may spread,
we remain unmoved,
secure in the knowledge
of the justice of our cause.

Doubtless they
will leave this world
crazed with anguish.

Our flourishing and triumph
shine with the brilliance of the sun.
And we know we will adorn
the final stages of this life
as the setting sun
paints the heavens
a deep and perfect crimson.

For their part,
the inner outcome
of cheap and superficial acts
will be endless distress.
Their hearts remain clouded
in pitiable angst—
desperately struggling
to maintain their façade,
they are tormented by the vanity
of their minds.
Savage brutes—
the frail and fleeting nature
of their inner being
is plain for all to see.

People who stain
the honor of their own life
suffer ultimate loss.
They are fated to misery,
pathetic and dangerous,
never to know the friendly,
welcoming gaze of others.

Each time they catch
a glimpse of their lives
they find their ugly inner conflict
mirrored straight back at them.

Family background, for example,
a source of constant boasting…
One such friend takes
endless pride in wealth.
Another overbearing friend
brags of position and rank.
Yet another has been overtaken
by the charms of rich attire
and treads proudly toward
misery's depths.

Others, caught up in
rude amusements,

wreak suffering on others
even as they give over
their abject souls
to the daily process of decay.

Ah, the stupidity that spews
its sad and ugly spell
over heaven and earth!

Those constantly
drunk on toxic draughts.
Those ignorant
of sane humanity
who know only night.
Directionless and flailing,
they fall tripping
into murky swamps,
sinking into forms of
fearsome bestiality
from which all light
has been denied.

I raise my voice
and call out to them:
Do not lose yourself in the maze.
Do not succumb
to the allure of squander.

Do not sink in bogs
of destruction and vanity!
Beware of all that
warps your humanity!

The purpose of living is happiness,
an outcome only determined
in the full and final measure
of a person's life.

This is why I urge:
Avoid blind belief!
Do not be trapped by arrogance!
Don't end up a tragic figure!
Live out your life
as a person of justice!

The Buddhist term "kosen-rufu"
signifies lasting, eternal peace.
It points to those dynamic realms
where individual happiness
and the flourishing of society
come together in perfect accord;
where all people,
—the living, breathing
whole of humankind—

savor genuine happiness;
where songs
that praise and glorify
life's innermost essence
are shared in conditions
of security and contentment.

* * *

No matter how the call
for vengeance
may justify it,
people must never kill
their fellow human beings.
For to do so is
hellish and brutal,
true tragedy
forever without redemption.

Where life is cherished,
there peace is found.
Where people are united
in the richness of their hearts,
there peace exists
as a tangible reality.

The advances of science
have increased
the convenience and ease
of all aspects of life.
And yet they have failed to realize
humanity's dream of happiness,
absolute and indestructible.

In its primordial essence
life is precious and
of infinite worth.
Where all is viewed
from the perspective of
life's precious dignity,
where this is the basis
for all actions and interactions,
there arises and is proved
the truth that guides
our universe.

The constant longing
of humanity's drumming heart
is for unbroken peace,
for peace without end,
embraced by eternities
of love and warm benevolence.

It is for days filled
with the joy of living,
the pleasures of friendship
and conversation.

We long for lives of freshness,
smiles and advancement,
consistently extending
over each event and facet
of humanity's long history—
from the past to the present
from the present into the future.

It is up to those senior
in life's experience
always to strive
to ease and requite
the sufferings of their juniors.

It is up to those who wield power
always to consider
how best to respond
to the fears and worries
of the people.

Every person's heart is regal,
yet also shares
a common humanity.

Into the precious, enduring heart
of a mother who has never
flinched or fled,
a warm light begins to flood,
cheering and revitalizing.

Crowds gather
in the morning mist
hailing, calling out their praise
for mothers and for peace.
Shining eyes,
directed at human happiness
and at peace,
filled with ageless wisdom.

I offer my solemn tribute
to you who have embraced
so many desperate people,
who have grown to become
proud and gifted teachers
of the soul's eternal songs.

In your life is inscribed
a monument to wisdom,
to victory and glory,
which no angry wind can topple,
no silted hostile torrent undermine.

Ah, the power you possess
as you resolutely rebuff
whatever storm assails you!
Your soul's sublimity
breaks open the dank and
hate-filled heart
where plots fester
and schemes breed.

We live in a society
filled with plaintive attempts
to escape responsibility.
Armed with conviction
you offer all people,
equally and without distinction,
your warm encouragement,
inspiring them
to elevate their lives
to strive for beauty,
for the noblest heights
of the human spirit.

* * *

As Socrates declared:
 What is important
 is not simply to live,
 but to live well.

As Victor Hugo cried:
 Young people, take heart.
 If there are those who would make
 the present difficult,
 our future will be beautiful.

However much some may
be showered in renown
and receive the heated cheers
of the multitude,
this is of little concern.

For the value and significance
of a person's life
must be assessed in its entirety.
We must ask:
Has this been a life
which brightly cast the light
of conviction and justice
over past, present and future—

like a jewel whose facets
mutually capture and reflect?

No matter how those
in positions of influence
may seek to deceive,
putting on the airs
of great statesmen,
we are not intimidated
in the least.

For there are many
wise citizens who
sense and respond acutely
to such subtle
and underhanded moves.
Their skin crawls
as if caterpillars were
creeping over their bodies.

My friend!
Sharing a celebratory toast,
let us envision the immense
scale of our future,
free from sorrowful sighs,
lit by ten million sparkling
points of light.

My dear friend,
in the midst of this demented era
you advance boldly, youthfully, powerfully
along the freshly open path
of the new century,
laughing grandly with
your friends and fellows.
Sounding the bell of conviction
you gather strength and empower
one another.

There, the sun's
pleasant, lively light awaits.
There line up
the adornments
of numberless stars.
And there await
friends passionately
sharing our convictions,
who peer with calm and easy smiles
into the deepest reaches
of our heart.

Most noble and precious
are such friends;
changeless, undiminished friends,
our eternal treasure.

Even if,
for the sake of truth,
we are together forced
to drain the bitter cup,
the time will surely come when
—now bathed in honor
and having shed all failure
or exhaustion—
we will address to all humanity
a proud acceptance speech
for the victory that is ours.

* * *

Emperors are human.
Ordinary citizens are human.
So are the powerful.
All people are.

Our true human worth
is determined by the state
of our inner life.
It is determined by
what we achieve.
And it is determined by
the nobility of the goals
toward which we strive.

In life, there are those
who are fortunate,
those who are unlucky;
there are the clever and sly,
the simple and honest.

Whatever one's rank or standing,
in an era of humanity,
it is utterly irrelevant.

Buddhism teaches that
if you want to understand
the causes made in the past,
look at the results
as they are manifest in the present.
And if you want to know
what results will be
manifest in the future,
look at the causes that exist in the present.

Life is eternal.
The workings of the law
of cause and effect
mean that the "you" of the past
is strictly reflected
in the actuality of your present.

And the reality of your future self
is forged by current action,
in your behavior now.

Each individual's heart
—various and extensive,
capable of evil and of good—
propagates and spreads
its influence like ringlet waves
overlapping on multiple dimensions.
The result can be an era of peace
or a world of conflict and war.

My friend,
my dear and treasured friend!
Pay no heed
to threats made by those whose
hearts are fractured and split,
who spin out words
of insane fabrication.

For you are in your dawning future,
and have no need
for mad and mercenary language.

My friend!
Upholding the dignity of life

maintain the calm
and confident manner
of one eternally victorious,
of one whose spirit sprints
swiftly ahead.

You who fight on
in resolute triumph,
never forget the vow
made that day
in the ancient depths
of your being!

Mouth and lips set
like sculpted stone,
together with
gentle friends
of firm faith
let us cross
the numberless crags
that stand before us.

With splendid effort
let us win and gain
the crown
of inner victory!

No matter what,
please win!
I also, am most assuredly
determined to win.

Salute this procession,
this triumphant march toward peace!

(June 2, 2001)

ꝏ AUGUST 15
The Dawn of a New Day

August 15
The Dawn of a New Day

August 15, 1945—
the day the Japanese nation,
led by arrogant, foolish leaders,
fell in defeat.

A day that marked the start
of a new era.
A day when the people's hearts
began to pulse again with joy
toward a new future.

A day of penitence
recalling the senseless
battlefield deaths
of so many millions
of loved ones.

A day of eternal parting
from sweethearts and lovers.
A day of tears
for mothers who would
never again see their dear children.
A day of hopeless heartbreak,

learning that young sons
—the future hope of their families
and society as a whole—
were never to return.
A day of anguished grief
as fathers, too, shed bitter tears…
The fifteenth of August—
Ah, August 15!

* * *

Stumbling in flight
from the raging flames
of aerial assaults,
so many died
in a lethal hail of lead.

Who was responsible?
Who would pay
or make amends
for these crimes?

Untold numbers of noncombatants
perished in the air raids—
running helter-skelter
through the fierce flames,

their hearts filled
with biting sorrow
and bitter outrage
at the stupidity of war.

Because of the war,
for the sake of their country,
so many men died,
so many women, too,
serving with the troops
in the battlefields.

It is wrong to view
the service and suffering of war
solely in terms of men's lives.
We must never forget
the courage of the women
who died in the dedicated
service of their country.

More important
than debating where
the souls of the fallen
should be enshrined
is that we never forget
the precious reality
of their lives.

Everyone is equal
in their humanity.
If we focus on this fact
—this principle, this law—
false distinctions disappear
and there is no reason
for fighting or conflict.
The challenge of the 21st century
is to firmly embrace this philosophy
of fundamental humanism
and to spread it throughout the world.

* * *

Even now these sights
are burned indelibly
in my heart.
In the midst of an air raid
in the middle of the night
an elderly couple shaking with fear
as they fled weaving their way
through the streets.

Also unforgettable
was this pitiful sight—
a group of middle-aged men,

apparently of some standing,
scampering in desperate rout
like trapped and panicked prisoners…

Our family saw
my four elder brothers,
all in the prime of life,
called away to war.
All four were made tools
of Japan's invasion of China.
My eldest brother
was sent to fight in Burma,
where he died in battle.

With heavy steps
my aged parents
waited and waited,
wondering when, oh, when
would he and
their other three sons
return.

In those days,
my father and my mother
rarely smiled.
Suffering from tuberculosis,
I did not know

what to say—nor to whom—
of my future hopes and dreams.
It was an era of people
drifting through the streets
lost in solitary sadness.

Each new day
left us more exposed
to the icy blasts
of a northern wind.
Everywhere the sight
of decent people
looking like those condemned
to climb the gallows stairs
at the unfeeling command
of brutal assassins.

It was a bitter outrage.
While hardship and suffering
were forced on ordinary citizens,
a handful of politicians
—the hypocrites in power—
seemed to mock us
dismissing and deriding us,
looking down on us
with intolerable arrogance.

None of us had wanted
this war.
We had never
accepted or supported it.

Yet over time
almost without noticing,
we were all influenced,
maneuvered and brainwashed
to extol the glories of war.

The human heart holds
terrible possibilities.
More terrible still
are those who use their power
to mold and manipulate
people's minds.

On August 15,
Japan was defeated,
utterly and totally defeated.

The haughty pride of Japan
was beaten and crushed
by the bombs and blades
of the counterassault.

Without doubt
there were many wise
and clear-sighted citizens
who actually cheered
their country's defeat.

Ordinary people had longed only
for a moment's peace of mind.
It was only natural that
they should want to see
divine retribution
—the cutting lash
of sharp remorse—
meted out on the heartless leaders
who had inflicted
this slave-like subjugation.

Ah, August 15, 1945!
That day the summer sky
was bright and brilliant.

At noon there was
a radio broadcast announcing
Japan's defeat.
Invincible Japan,
so certain of victory,

had been thoroughly beaten.
Many wept,
but far more, no doubt,
felt relief
deep in their hearts.

The summer sky,
where once we had watched
enemy planes,
was now incredibly quiet,
and red dragonflies
flitted gaily through the air.
Japan, which had declared itself
the invincible land of the gods,
lay in utter ruin.

* * *

My family had been forced
to evacuate our home,
to stay with relatives
in Nishi Magome.
However, this refuge,
this house set amid peaceful fields,
took a direct hit
from an incendiary bomb.

With all our worldly
possessions inside,
it was instantly engulfed in flame.

With our relatives' consent,
my father constructed a tiny hut
on the same lot,
with a small sheet
of scorched tin for a roof.
We had no mosquito netting,
so now, instead of bombs,
we faced the assault
of squadrons of mosquitoes.

On that day of August 15,
my father, face flushed with emotion,
murmured to himself,
"My sons will now return.
My eldest, Kiichi,
my second, Masuo,
my third, Kaizo,
and my fourth, Kiyonobu,
are coming home.
One from Burma
three from China—
they're coming home."

He uttered these words,
breath catching painfully
in his chest,
as one awakening
from a dream.

My diminutive mother
prepared dinner,
excited as a young girl:
"How bright it is!
Now we can keep the lights on!
How lovely and bright!"

That summer,
my father was fifty-seven,
my mother forty-nine,
and I was seventeen.

August 15 was the day,
the moment we emerged from a
deep and hellish gloom,
regaining as a family
some happiness and cheer.

Although some of my siblings
wept at Japan's defeat,

deep inside everyone was relieved:
How good, they thought,
how good that the war
is over at last.

Eventually
the sad news came—
my eldest brother
was dead,
killed in action in Burma.

While many were discharged
and returned quickly
to their homes,
one year passed,
and then another,
before each of my
three surviving brothers
managed to return home
quietly alive.

All three,
unable to feel
the new era's hope,
returned dazed
with forced smiles
on their faces.

"Thank goodness!"—
beyond this simple
phrase repeated,
parent and child
could find no words to share.

* * *

Our home-life shattered,
our family tossed down
to misery's depths…
But we were hardly alone,
countless people wept tears
of anguished suffering
and heaving grief.
Each year I greet
this day of August 15
my heart filled with outrage.

The years of youth
which should be
the time in life
most burning and blossoming
with hope,
were ruined, distorted and despoiled,
the purest sentiments
crushed underfoot.

With the coming
of this day each year
my sorrow at the pain and loss
turns to boiling rage.

August 15—
is this not the day each year
when Japan's leaders
should prostrate themselves
before the people?
Is this not the day
when you should
vow to consecrate your lives
to the people
to the cause of peace,
the day when you should
promise to work
with unstinting devotion
for the happiness
of all people?

With what words
would those eminent scholars
who had extolled war's glories
now apologize,

their heads bowed low
before their youthful students?

The famous who,
festooned with honors,
had sung war's praises—
now bowing deeply in apology
to the common people,
backs bent and
shoulders drooping.
No doubt there were many
who could feel only
contempt at this sight.

We experienced the truth
that demonic evil
plainly contains
the seeds of its own destruction.

Those who would lead
must never, for all eternity, forget
the pain and suffering
—the dank prison torture—
undergone by people everywhere
because of bombardment,
military assault and warfare.

* * *

Royalty are human.
The immensely rich are human.
The great and powerful are human.
And we, we ordinary citizens,
are human.
Nothing can therefore justify
causing people
to be tossed by tempests of misery,
to have poison forced
into their sacrosanct bodies,
simply to benefit
the powerful few.

The 19th-century Ukrainian poet
Lesya Ukrainka wrote:
> The predawn light,
> heralding the sun's arrival,
> dispels the darkness of night.
> In that time
> when the sun has not yet risen—
> the predawn light blazes
> and illuminates the sky.
> You who are awake, arise!
> The time to fight is here!

We have arisen!
We have arisen
for the goal of world peace
which we call kosen-rufu!

Day after day,
those who came before us,
made noble by their dedication,
took on the arduous challenge
to scale the daunting heights
of this quest for peace.
We will carry on
the work of those noble pioneers,
reaching the goal without fail!

This is the path of humanity.
It is the path of faith.
It is the path of peace,
the path of truth and justice.

August 15—
We must never forget
the painful misery of that day.
We must never forget
the desolation of that day.
And we must never forget
that humiliating awakening
to the folly of slavish obedience.

August 15—
Let us make this day
a day praised by all
the people of Asia.
Let us make this day
a day respected by all
the world's citizens.

This day of
August 15, 2001—
this is a day of fresh departure
for the youth of the new century.
It is a day
to be eternally commemorated
as a day of peace,
as the start of a new era of life.

(August 14, 2001)

IN JOYOUS TUMULT
Unfurling the Banner of Humanism

IN JOYOUS TUMULT
Unfurling the Banner of Humanism

This life I live—
where did it come from?
where is it going?
The very core of life
should, I would think,
be eternal.

For what purpose
was I born,
why as this
particular person?

And why
in this country,
this home,
bearing this
special destiny?

These are things
known to no one,
for which no amount
of questioning

will bring a clear response.
These are things
unknown even to ourselves…

For what purpose, then,
do we continue
to live this life,
this precious
span of being?

Why were we
born human?
Could we not
have taken
other form?

Were we somehow aware,
in the vast reaches of space,
of this planet Earth?

What fate caused me
to be born—
in this small dwelling
in this particular village
here on Earth?

So many doubts and questions,
so many imponderable realities.
And yet we must continue to live...

Some are born
in mansions.
Some on palatial estates.
Some people
receive the gift of life
in poor and simple homes.
Some are born
shouldering the burden
of illness.

Everyone is born into this world
bearing a unique destiny—
the distinctions and variation
are limitless.
This is neither illusion
nor abstraction;
it is solemn fact.
Some have wise fathers
of established social standing.
Some have foolish fathers
trapped in suffering and scandal.
Some grow up
in families divided by divorce.

With every coming day
the struggle to understand
the true nature
of life continues.

Though you live
with the purest intentions
you may find yourself issuing
a blasphemous cry
at life's discontents
and contradictions.

Who is a person of justice?
Who lives fully in truth?
How do we realize
the timeless promise
of our lives?

Seeking life's
true essence,
its unfathomable depths,
fifty or sixty years pass,
never to return.

For those
whose hearts

are pale and wan,
there is no burning
of the blood,
no hot and healthful
flow of sweat.

* * *

The heavens
look down upon
humanity
and laugh.

There is strife among people,
like the constant
sharp stabbing
of barbed thorns,
war between countries,
conflict within regions—
an asinine procession
of humanity clutching after
dull-witted power,
as if they've been taking
opium since birth.

Nothing is more terrible
than the enticements
of the powerful.
Swollen with ambition,
from their high windows
they watch and sneer.
This is a reality
with which we are
all too familiar.

Ours is an age
of depraved corruption,
of criminal evil,
of hellish misery—
why do those
who wield influence
make no effort
to resist these trends?

Why don't they give their all
to achieve peace?
For a person of
genuine integrity
peace should be
the paramount objective.

The responsibility
of those who hold power
is fundamentally grave.
Yet it seems their minds
are always upended,
an inversion of what
could be called
normal or healthy.
The stances they take
are ugly and base,
and they offer
no hint of giving them up.

When, we must ask, do you intend
to show some sign
of real sincerity?

You who wield power!
It is up to you
to offer the world
the highest example and model.
By rights you should be poets,
people of refinement
and compassion,
historians engaged
in the work of building peace.

In the words
of a wise child—
Discard the symbols
of authority you have
so proudly pinned
to your chest!

Acts of suppression
based on a willful
refusal to understand
will bring the dissolution
of your own mind.
Pressuring and constraining
true activists for peace
is an act
of self-strangulation.

The world has had its share
of truly frightening
geniuses of evil.
Wielding ferocious authority,
crazed with jealousy,
throughout history
they have continued
to drive out and destroy
pacifists and people of justice.
They must always be resisted.

While they may possess
the immense power
of stratagems and schemes,
we can resist,
struggle and win
with an even greater force,
the power of right.

Crude and brutal,
they take pleasure
in obliterating truth,
annihilating happiness.

We work
to bring into being
an august and dignified land
of justice, happiness and peace.
Our efforts consistently resound
with the robust, symphonic tones
of construction.

Here there is no
class struggle.
Ours is a humanism
in which all are equal.
Here there are no vanquished
and no victors.

Everyone is triumphant
in happiness.
Everyone is a builder
of justice.
Powerfully embracing
our rights,
we continue
to exalt and uplift
a new world
of the human spirit.

This unprecedented effort
to generate a new direction
in human history!
Committed to this vast task
of reform and flourishing,
a new humanity,
gleaming with determination,
gathers dancing
on the distant horizon.

Leaders must be people
who ceaselessly pursue truth,
whose hearts are filled
with the joyous flood
of a sense of mission.

The dominions commanded
by haughty power
eventually fall
into riot and rebellion,
bitter chaos and misery.

The ultimate sorrow
is to be led by those
who use their power
to manipulate the many
into madness—
smirking proudly
all the while.

Only when the people
bravely relinquish
the cause of their regrets
will waves
of great joy arise,
and people
be celebrated
as people.

Then we will welcome
an era of genuine peace
where none can restrain
their spontaneous smiles.

* * *

The demonic nature
of power has been
known and acknowledged
since ancient times.

Though the family and clan
of the mighty
may prosper now,
one day the freshly raised shouts
of the multitude
—aided by old friends awakened—
will expose the inner workings
of their authority,
and a decisive counterassault
will begin.

The underside
of the pomp and prestige
of those boasting glory
is their inevitably
grim final fate.

The joy of the common people,
the happiness of ordinary citizens,
requires restraining the powerful

bringing them back
to the same plane
that we inhabit.

This is the only way to create
a society of peace,
an era of humanity,
that makes real sense
to everyone.

Here there are no more
pained and tragic shrieks.
A spirit of vibrant equality
quells all imbecile strife.

In humanity's early ages
the incisive tools
of civilization did not exist;
organized warfare was unknown.
Satisfactions were small, perhaps,
but so also was the scale of suffering.

The twenty-first century
is an age of atomic energy.
Compared to those early,
simpler days,
everything has developed

and progressed;
knowledge and technology
have advanced.
Surely this requires
that a commensurately
great happiness
be unleashed and allowed
to spring from the nest.

* * *

Ignorance of
a clear and certain
purpose in life—
this is the root cause of
all unhappiness.
I heartily embrace
the truth of these words.

One renowned statesman
called out:
We must revolutionize
the benighted worldview
that asserts that peace
is but the interval
between one war
and the next.

To that end,
we must revolutionize
human beings,
the protagonists of history.

Politicians!
Are the cries of your soul
free from falsehood?
For we will no longer tolerate
your agile lies!

You hold in your hands
the power to make
this land a place
raging with storms
of sorrowful sighs,
an endless expanse
of charred ruins.

What people
yearn for and await
is to be able to set foot
anywhere on Earth
and find that place pervaded
with a deep sense of happiness,
fulfillment and purpose in living.

Those who would wield
arbitrary power—
nothing is more despicable,
nothing more inexcusable,
than to calmly greet
the frightful evening's pleasures
even as you bring about
the downfall of people
whose only wish
is happiness in this life!

The people
raise their voice
and cry out.
Like a great wind
like raging billows
they cry out, unflinching,
with inexorable resolve.

We will not be defeated!
This is their roar—
we will not be defeated
by ruthless and arrogant power,
by those who
turn a blind eye
to these painful shackles,

to the many sad
and shattered lives.
We will not be defeated
by those who forget respect
and look on us
with scorn-filled eyes!

The shedding of
tears and yet more tears!
Because of war,
because of conflict,
how many tens of millions
have borne up and endured all,
struggling to hold back
their anguished cries?

Amidst storms of fate,
a life gone berserk,
they have lived with all their might
clinging to the edge
of an ocean of tears.

We must absolutely
put an end to war!

The cause of war
is the ignorance

and reckless arrogance
of the powerful few.
The result is people
robbed and deprived
of an irreplaceable lover,
a husband, a child.
Statesmen must never
forget these victims,
their utter wretchedness
and despair.

We have absolutely no need
for false shows of deference
or for flattery.
For these are but
the loud, coarse laughter
that ridicules us ordinary folk.
The people
may appear foolish,
yet they embody
a supreme wisdom.
We will never
again be fooled.
Never again
can we allow ourselves
to be deceived.

However loudly
gutless leaders
may sound their bugles
and give confounding speeches,
the people already have
an unforgiving knowledge
of power's poisoned claws.

Politicians,
stop your posing and pretense!
This is the voiceless voice
of people everywhere.

* * *

How to overcome
life's fateful sorrow?
More, how to meet
the solemn pain
of death and bereavement?

And how to respond
to dark, downcast days
provoked by the schemes,
attacks and injustices
of this world?

How to endure
the agonies of misfortune,
as sly ones launch their assault
chortling like the rhythmic tapping
of funerary gongs?

So many people are crying.
So many people grieve.
Who will offer love and comfort
to hearts injured
by undeniable injustice?

Today, once more,
a life chilled
by north winds
and by a damp, cold rain.
A life that must be lived
enduring severe
and odious anguish.

This is an unjust world
in which the righteous suffer
and false ones
amass astonishing riches,
strutting about
with self-important airs.

Everyone has the right
to savor the highest joys.
Everyone has beautiful hopes
that must not be violated.

Utterly dedicated
to the dictates of conscience,
to the service of people,
we continue this endless advance
along the path of right.
Before us lie storms
of vicious falsehood and intrigue,
irresponsible plots
that would spread
a venomous disgrace.

Yet with calm and dignity
we overcome
the continuing succession
of hardships.

We revolutionize ourselves.
We have begun to possess
the most uncommon
kind of strength.

We do not even
turn to acknowledge
the lure of malicious hearts,
or other corrupt seductions.
We laugh off
harassments without number.

The feeble voice that
once flowed seeping
from our chests
has changed unrecognizably—
into swelling cadences
of gravity and conviction.

We have withstood all trials
and we have won.
We have triumphed over
the language
of prejudice and discrimination.

My friend, your lofty spirit
has serenely transcended
all forms of threatening violence
and the treacherous
words of hacks.

You are surrounded and embraced
by voices of joyful song
welling steadily forth.
The time has arrived
to dismiss with laughter
those who spin
their base and nasty schemes.
The sound of that laughter
grows to the beat
of wings stretched wide.

We have risen above
the foaming waves
of slur and slander,
unprincipled words
whose only purpose is
to sell, to feed
to profit and
to give vent to envy.

* * *

There are innumerable instances
in which the pioneers of peace
living in dedicated commitment to truth,
in which even the peaceful

practitioners of Buddhism
upholding what is correct,
challenging injustice,
have been persecuted and abused
by those who manipulate authority
with false and jealous words.
The shameless screeches
of those who crave power!

This indeed is the pattern
of persecution that
the sage Nichiren described.

Yet three generations of
mentor and disciple
were triumphant;
the victory of justice
like a clear blue sky.*

Precisely because
we live in an evil age
overflowing with defilements,
the lucid vision of the Buddha
—perceiving the three existences
of past, present and future—
shines ever more brightly.

The value of Buddhism
lies in its elucidation
of principles for living.
The evil nature of authority
lies in its malicious distortions
and destructive intent.

* * *

Do not fear
even the greatest hardships.
Do not flinch
whatever sufferings may occur.

Fear itself is unhappiness.
To shrink back only invites misery.
Those who cannot fight
have already been defeated.
Those who hesitate
become stragglers.

Remain serene
whatever cruel blows
may assail you.
Remain cheerful
however long
the days of

painful oppression continue.
For then you will be
a true champion
of humanity.

Ah, the people!
The ceaseless tolling
of truth's carillon tones.

The youthful solidarity
of valiant spirits
toppling unjust authority.
In joyous tumult
we are creating our own era,
unfurling high
the banner of humanism.

Ears attuned to song,
let the sunlight flood
the joy-filled depths
of your being!
In the fellowship of friends,
set out upon
this joyous path of peace!

(October 18, 2001)

Translator's note: The founding president of the Soka Gakkai lay Buddhist association, Tsunesaburo Makiguchi, and his closest follower, Josei Toda, were imprisoned in Tokyo during World War II for their criticism of the militarist government; Makiguchi died in prison in 1944. Toda survived and became the organization's second president. The author, who saw Toda as his mentor, succeeded him as president in 1960. Three years earlier, during a political campaign, Ikeda had been arrested on charges of infringing electoral laws; after a four-year trial, the charges were deemed baseless and Ikeda was found innocent.

THE PATH OF HUMAN REVOLUTION

THE PATH OF HUMAN REVOLUTION
In commemoration of United Nations Day

All people have the right
to live in peace!

Leaders of nations
who cast peace-loving people
into war's conflagration
—inflicting on them
that horrific suffering—
epitomize evil.
Their crimes can never
be forgotten or forgiven.

What is needed now
is for each individual
to become stronger,
to check and triumph
over authority.
To do this is our right.

We struggle
and raise our voices loud
in order that we may live
lives of wonder and joy.

Never believe
that the greatest,
most irresistible force
is the power of the state.
For the energy of the soul,
the might of the human spirit,
is an even greater force,
the most magnificent
power of all.

Let us form in our hearts
the resolute will to realize peace,
summoning a force
sublime and unsurpassed.
This is the goal and conclusion
sought by all of
humanity's wisdom and learning
over the ages.

To sway aimlessly
in the maneuvering winds
of the powerful proves
obedient submission
to physical coercion.

Those who work for peace
should inspire each other,

freeing the spirit's
most earnest aspirations.
We must always regard
the nightmare of war
—this doomed and criminal sin—
as the gravest stain
on human history.

Never chaotic or flustered,
let us strike out toward the future,
manifesting unparalleled strength.
Let us leave our mark on history,
a worthy marshalling toward peace;
and let this mark be precise,
built and based
on our robust solidarity.

Throughout history
humanity has
endured so much,
gazing always
at the distant dream—
persevering in anticipation
of the day when we will
live together in peace.

Always be on guard
against apathy.
For apathy inflates
ill-defined egos,
making them vulnerable
to virulent strains
of nationalism.

In the words of
the Austrian writer
Stephan Zweig:
 We must counter
 the organizations of war
 with an organization of peace.

In precise accord
with this timeless insight,
we are organizing for peace
undeterred by any obstacle.

Pioneers of unknown paths
invariably meet with
slander and abuse.
Yet inspired philosophers
and visionaries bequeath us
the enduring genius
of their words.

Mahatma Gandhi:
> Our struggles are efforts
> aimed at creating friendship
> with the entire world.
> Non-violence was born
> as the way of humanity
> and its necessity has not yet ended.
> This is the pioneering path
> of world peace.

* * *

Humanity will never know
that place which is perfect
and without flaw.

But when will we succeed
in the eternal challenge
—this struggle ceaselessly repeated—
to transform our ideals,
the destined promise of peace,
into reality?

It is the duty
of all students
of power and of history

to expose and put an end
to the duplicitous
tactics of diplomacy;
to make a lasting and decisive
correction to the errors of the past;
to strive sincerely to resolve
all impediments
to the unity
of the world's peoples.

Everyone
has the right to live.
No one
has the right
to take another's life.

We must never forget
the yearning for happiness and peace
that kindles brightly
in the deepest reaches
of the hallowed soul
of every man, woman and child.

How deep
is human ignorance?
How lofty
is human intellect and spirituality?

Who exactly is the enemy?
To what end
are wars really waged?

Are not the principles
and ideals of global citizenship
—the dream of peace
pursued since the dawn of history—
now ripe for realization?
Was not the United Nations founded
to assure the peace and security
of all the world's citizens?

The Charter of the United Nations
is a powerfully resonant declaration,
a treasure of vision and conviction.
We must make it the core
of a new and global tradition of peace.

Toward this end,
we must wish that its structures
be imbued with confidence and allure,
that the spirit to champion peace
sink roots deep into the earth,
and that there will flourish

a clear and vibrant
sense of purpose.

* * *

Politicians,
what is the goal
of your activities?
Statesmen,
to what end do you wield
power and authority?

Please be finished
with your inane self-promotion.
And put an end
to your threatening rhetoric as well.
We've had enough
of meaningless efforts
that pretend to be surgical.

Because all that awaits those
who abandon the course
and commitment to peace
is a life of emptiness,
the capricious pursuit
of personal profit.

As Erasmus once asked:
Is not the world
the common fatherland
of all people?

With the arrival
of this long-awaited century,
people everywhere,
from all the distant corners
of this Earth
wish for peace
in the company
of fresh and delicate flowers.
They long for a life
of confidence and joy,
where "all living beings
are happy and at ease."

Their minds contain nothing
of the crass machinations
that take highest delight
in grasping after power.

Hurriedly seeking
the towering dream,
they anticipate the arrival of

a new and yearned-for world
of enduring peace.

Enough already
of the sickening shriek
of artillery fire!
Enough already
of the daily raids
of pitch-black storms!

We wish absolutely
to take a stand against those
who would fill our lives
with endless, grief-stricken cries.

Enough of war,
of conflict,
of riot and unrest,
of hair standing on end
in tempests unleashed by
the lightning outbursts
of leaders
madly bereft
of all compassion.

Statesmen of the world,
heed our words:

Learn to satisfy your pride
in service to your citizens.

Statesmen of the world:
Never forget
the ages of searing anguish
that have been endured
to this day!
Never, ever forget
the children,
all your fellow humans
scrambling desperately
through indescribable horrors—
faces ashen with fear.

People without number
have fallen
on the hellish path of war.
They have passed
from this world
in twilight rains,
writhing in anguish,
blood oozing
from their mouths and wounds.

Who can believe
that spirited person,

those boys so radiant with hope,
are gone!

In the far moonlight
young friends
who shared a love,
bid aching, forlorn farewell,
in stunned stupefaction.

Theirs was to be a life
of freshness and wonder…
Now their still
and soulless forms
are embraced only
by the mournful patter
of spring rain.

Not even the crimson clouds
of the day's afterglow
can be seen in the distance.
Not even a hint
of the setting sun's
golden rays.

Where can we find
the lifeless bodies

of these two?
Where are
their departed souls?
We want to be answered.
We want to be told.

Statesmen of the world:
You should be blessing
all people everywhere
with songs that celebrate
love's union.
You should encourage
and lift people's hearts
with odes to humanity's triumph.

Victor Hugo declared
that a true political leader
is someone who,
confronting the reality
of even one person suffering
in poverty,
devotes every thought
and takes every action
for that person's welfare and happiness.

Tears rise at
the simple yet profound

truth of Hugo's insistence
that elected officials
be servants of the people.

Even those who share
no common language,
who cannot speak directly
to each other,
can forestall and resolve
the ultimate misery of
violent conflict
if the wellsprings
of their hearts are filled
with a deep love
for life itself.

You cannot claim justice
unless you exhaust
all words and actions
to prevent war—
with your last drop of strength,
to the last moment of life.
Nor can you lay claim
to the compassion
of a genuinely complete
human being.

It is a fact
that we all
must someday die.
They also, on their side,
will one day die.
That everyone
must someday die
is universal.

For this very reason
we should dedicate ourselves
to the enduring work
of building a world of peace
overflowing with the spirit
of happiness and compassion.

What could possibly
be the point
of a life spent
injuring oneself,
killing and harming others?
To do so only proves
the soul's servitude
to fear.

Homes however humble
can be palaces of peace

where people live in harmony
as parents and children,
brothers and sisters.
Such abodes are fragrant
with mutual affection,
free from loneliness.
They are caressed
by the warm winds of peace,
breezes of tender cheer.

Here are hearts
with no dark clouds,
no cold drizzle,
where the welcome sun
bursts forth from within
shedding protective rays
on all of you
and on us also.

* * *

My friend,
do not spend your days
chasing petty dreams
only to fall behind
the forward movement
of the times.

My friend,
do not play the fool drawn
to vainglorious dreams;
for these are but one
of life's many masquerades.

Yes, my dear friend,
let us together perform
the symphonic tones
of life's triumph—
smiling serenely
violin bows quivering
higher, ever higher.

Rather than a life
of affected heroism,
live a life genuinely heroic
rooted firmly in reality.

However the times may change,
or how people may treat you,
I urge you, my friend:
Set forth upon a noble voyage
in pursuit of your beliefs.
Shining brilliantly
in the midst of driving
winds and rain,

follow without pause
the dreams and goals
that are your life.

Arise, my friend!
Stand up to lead
a life supreme!
Bid farewell forever
to a life of quaking
fear and grief!

Never be one
who wears a doomed expression
and moves crawling
through darkened spaces.

My friend,
stride forth upon
this true, this certain
this highest path,
to fulfill your purpose in life,
to advance the struggle for peace.

Never be ensnared by
the sinister at heart

or sow the seeds
of your own regret.
Do not live lured
by sweet illusion
to become a pathetic shadow
incapable of feeling pain.

Let today,
let this year,
blossom with spring
in the manner most appropriate
to the person
you uniquely are!

Frequent and deep
may be your sighs.
Yet still, continue to listen
to that joyous inner voice,
examine your life with wisdom
exerting yourself without cease.
Go, then, and prevail!

From beginning to end
wage this effort
to earn the victory
of your eternally enduring self.

Opening as you do so
the resolute path
to an era of human revolution!

(October 24, 2001)

THE PROMISE OF A MAJESTIC PEACE

The Promise of a Majestic Peace

Long have I walked
the roads of this world,
leaving behind
so many memories,
creating my own history.

I have no regrets.
For in my justice-loving heart
has burned the flame
of compassionate determination
to rid the world
of fear and war.

Nameless,
I have known the joy
of innumerable struggles,
the diverse, resounding cheers
of so many friends.

I have forged
broad, new paths for peace.
With the passion of my youth,

with brightly burning eyes,
I sought to create
an ideal world
such as people have dreamed of.

I have always stood,
have always walked,
have always fought,
in the light of happiness
that is the Mystic Law.

Closing tired eyes,
I recall how
I ceaselessly raised
the cry of justice,
scarcely pausing
for a breath.

Worldwide kosen-rufu
signifies world peace.
Nothing remains to me,
I have no other wish,
than the realization
of that dream.

However trying
the realities

of daily life,
the motivation of my heart
has always been
the world's peace.

There have been
bright and beautiful
seasons of spring.
There have been days
when the closing fog
obscured everything.
These memories
are already part
of the distant past,
and yet they are the source
of an energy that is
deep and powerful
and wondrous.

In the words
of the American poet
Walt Whitman:
 I would be the boldest and truest
 being of the universe.

I know that
with the coming

of each new day,
I have prayed
and taken action
for the peace of the world.
Thus my heart
is fulfilled and satisfied.
Like the stars
that sparkle
in the highest reaches,
I know that I have won.

Peace is humanity's greatest,
most solemn undertaking.

While the limitless progress
of scientific advance
has enhanced the means
of killing people,
still the promise
of a majestic peace,
the kind required for us
to live humanely
—the determination
to realize such a peace
in perpetuity—
remains unfulfilled.

Albert Einstein
stated that
human beings must
continue to fight.
But they must fight
for something whose value
justifies the struggle.
And he declared that
their "arms" should be
"weapons of the spirit."

* * *

Vacant stares fixed
on piteous, desolate ruin.
For what purpose
have we lived?
To what end
this violent strife?
The only response
is the howling
of an infinitely empty wind.

The unsound nature
of those who
continue to bring

this sorrow and suffering
to people like us
—we who have had
no say whatsoever
in any of this—
it is this nature
that we must absolutely
transform and change.

The utter brutality
that can casually
rob others of life!
The madness and folly of power
pillaging the last scraps
of happiness.

Demonic authority
that strips everything
from those honest,
good-natured people
who have exerted
every effort to live,
carrying in their hearts hope
for the simple
happiness of spring.

In the contemptuous glare
that does not recognize
people as people,
the human heart is absent;
there is only something
monstrous and bestial.

For both victor
and vanquished,
war leaves only
a sense of endless futility.
Whose responsibility is this?
The answer should be clear,
and yet it is not.

* * *

Our happiness,
our peace,
must be inviolable.
We must never permit
our right to happiness,
our right to peace
to be abused or trampled
by those possessed
by cold brutality.

Even in the depths
of the darkest night,
when all is obscurity
and decline,
we must never allow
the light of peace
to be extinguished.

Whatever the sway,
the back and forth
of clamoring debate,
of slanderous abuse,
keep the sun of peace
shining bright and firm
in your proud, triumphant
and tireless soul.

Those who would run and flee
may do so.
The treacherous
may do their worst.
Those who would loose
the poisoned darts
of calumnious envy
may do as they please.

Champions whose wealth
is their commitment to humanity,
monarchs working for peace,
fear nothing, nothing at all.
For our spirits
are eternal and indestructible.

* * *

Today again
the night comes.
So many people
are weeping
in the gloom.
All are huddled
fearful and silent
in the lightless dark.

Nowhere are there any
brightly lit homes.
No—
each person's very soul
is oppressed by darkness.

Hearts fraught,
weighted down

with an indescribable burden—
how much longer
will this exhaustion continue?
When will it become possible
to feel hope or happiness?

It isn't fair, it isn't right.
Why are we tormented
and made to suffer?
Why do those with the power
to do so make no
attempt to help us?
Ah, to quickly leave
this life behind!

What in the world
is this life all about?
For what purpose
have we been living?
Surely it is not
to wage war,
to suffer like this,
to tremble in terror
or to wail out loud.

We should like
to see the day

when menacing tyranny
takes flight
and runs away.
And we wish
to tell future generations
how the potent flames
of our joyous commitment
to justice
burned high.

The agony of days
under merciless
aerial attack.
The unbearable sorrow
of ordinary citizens
fleeing in confusion,
desperate to survive.
The carnage of war
has changed all
life's joys
instantly to sadness.

Without a moment's hesitation
war has cruelly torn
happiness and peace
from the beautiful hearts

of families living earnestly,
from the inner nobility of their lives.

The glory of which
we dreamed
has been completely
and utterly destroyed.
It isn't fair, it isn't right.
We envy the birds
who can fly from here.

Even in daytime,
there is darkness
in the depths of our lives.
Night brings the further dark
of horror and pain.
Time's passage
brings only more
trembling in terror
at the accusatory tone
of the enemy's voice.
The regal spirit of peace,
the crown of life's dignity,
has been debased to something
worse than servility.

You who arrogantly
abuse your power!
How do you plan
to compensate
for grinding into the earth
the hopes and dreams
of honest citizens?

Citizens of loyal heart
have been cast aside.
And the powerful,
as if having pulled off
a brilliant performance,
recognizing no existence
other than their own,
commit grave
and eternally enduring
crimes against
the dignity of life.

* * *

The undying wish
of ordinary citizens
is for real and lasting peace.
Never become

a person of sad,
unprotesting silence!

The ancient Greek poet
Sophocles proclaimed:
 If there is truth in one's words
 one possesses the greatest strength.

We must give full
and unrelenting voice
to the call for justice
in order to realize peace,
in order to achieve happiness.
In such actions above all
will be found
a bright and happy future.

There is absolutely
no place in our world
for bloodstained children.
Such are the monstrous deeds
of those who have
abandoned their humanity.

Those who wield power
must never use it

to wreak tragedy,
to fill people's lives
with agony and grief.
No one,
absolutely no one,
has the right to do that.

To transform
days of tragedy
into days of happiness,
days of anguish
into days of peace.

The purpose of our lives
is for all to spend our days
smiling happily.
This is the real responsibility
of those in positions of power.

Political leaders!
Do not harm
the already despairing,
but make it possible
for them to experience
heartfelt joy.

Your purpose
must be to enable
the people's
efforts and struggles
to blossom in happiness.
It must be to create
the peaceful stage
on which they may enjoy
the dance of life.

To this end,
you must respect the people
and you must earn their trust.
"The people are emperor."
Now more than ever,
engrave these words of
Sun Yat-sen
deeply in your heart.

Thus will you qualify yourselves
to be true world leaders,
champions of the sovereign people.

In Einstein's impassioned cry:
We must try to awaken in people
a sense of solidarity that will not stop
at national borders.

History is in
ceaseless motion.
And with it the people's
wisdom and discernment grow.
Do not overlook the fact
that with every passing day
they stretch their wings
and stroke through the air
with ever greater wisdom.

Ringleaders of violent turmoil
plunge all
into the deepest pits of misery,
leaving them
weeping there.

"Evil leaders depart!"
This is the cry
of all people everywhere.

Our desire is to walk
with our intimate friends
beneath the cherries' full bloom,
inhaling the fragrance of peace,
caressed by warm breezes
and sharing our hopes
in pleasant conversation.

Strike the bell signaling
the arrival of peace!
Firmly sound the resonant chimes
announcing peace,
announcing victory
to people everywhere.
From a dark and blackened sun
raise your sights,
and regard the brilliant
sun of peace!

(April 2, 2003)

Daisaku Ikeda was born in Tokyo on January 2, 1928. He is a leading Buddhist philosopher and a prolific writer who has published over 100 works. As well as poetry, he writes on topics related to peace, education and the human condition.

Ikeda's life was fundamentally shaped by his youthful experience of World War II and his eldest brother's accounts of the atrocities committed by the Japanese military in China. The search for a means to root out the fundamental causes of human conflict thus became a driving force in his life from a young age.

After the war, Ikeda came to embrace Buddhism through his encounter with Josei Toda, leader of the Soka Gakkai lay Buddhist group. In 1960, he succeeded Toda as head of the Soka Gakkai and he has played a central role in the spread and development of Nichiren Buddhism outside Japan. He is currently president of Soka Gakkai International (SGI).

Ikeda has published one major collection of his poetry in English, *Songs from My Heart,* and many volumes in Japanese. He is founder of the Institute of Oriental Philosophy, the Boston Research Center for the 21st Century, the Toda Institute for Global Peace and Policy Research and the Soka education system.